FRED ASTAIRE
STYLE

© 2013 Assouline Publishing for the present edition
601 West 26th Street, 18th floor
New York, NY 10001, USA
Tel.: 212-989-6769 Fax: 212-647-0005
www.assouline.com
ISBN: 9782843236778
Color separation: Gravor (Switzerland)
Printed in China 🌿

FRED ASTAIRE
STYLE

G. BRUCE BOYER

ASSOULINE

astaire was never what we'd come to expect from our romantic heroes, celluloid or otherwise. Our ideals of handsomeness in the first third of the twentieth century ran more toward the dashing, athletic Douglas Fairbanks, the smoldering Valentino, the rugged Clark Gable. Even Gene Raymond, the almost "pretty" male lead in *Flying Down to Rio* (1933), in which Astaire and Rogers were first paired, was considered much more handsome at the time. Astaire was cast as the affable buddy, buoyant and brash, and a bit naive. On the few occasions when he talked about his appearance, he thought he looked more like Stan Laurel, the weepy silent film comedian, than anyone. But he made us think that perhaps, with a little practice, we could dance like him and win the heart of someone like Ginger Rogers. A dozen films later, he was still telling beautiful women—in this case Rita Hayworth, in *You Were Never Lovelier* (1942)—that he was just "a plain, ordinary guy from Omaha, Nebraska." He made it look easy. He made us think style was our birthright.

He was born a year before the twentieth century began, the son of a brewery employee in Omaha, and by the time he was 24, he was the toast of the New York and London stage and social scene. In another ten years, he would be a top star in Hollywood, eventually making forty films—a dozen of them now considered classics—and receive a Lifetime Achievement Award from the

American Film Institute. Irving Berlin once said, "I'd rather have Fred Astaire sing my songs than anyone else," a sentiment that could as easily have been echoed by Cole Porter, the Gershwins, and every other important songwriter in the first half of the twentieth century. As it happens, more songs were written for Astaire than for Bing Crobsy and Frank Sinatra combined. Both Balanchine and Jerome Robbins said he was the greatest, most original dancer who ever lived. Merce Cunningham and Margot Fonteyn called him a genius. Rudolf Nureyev, who found it difficult to give unqualified praise to anyone, said he was merely "the greatest American dancer in American history." For millions of moviegoers, he defined a film genre.

but it was, superficially at least, all rather odd. For Astaire was neither tall, nor dark, nor handsome— at a time when at least two out of the three were considered essential for success as a leading man in the new American cinema. He was, in fact, almost emaciated, of average height, balding, and ordinary looking in an impish, Peter Pan sort of way. His voice was thin, slightly reedy, and warbling. The writer Graham Greene compared him to Mickey Mouse, while one Broadway critic likened his face to "the shape of a Bartlett pear." He wasn't even much of an actor in those films that made him a household name. In his autobiography, Astaire noted that early on, a theatre critic had said: "Of course, you never would pick Fred Astaire out of any lineup to play a romantic hero, with or without music." And Astaire himself often repeated a studio official's response to his screen test: "Can't act. Slightly bald.

Also dances." After watching Astaire's first screen test, MGM producer David O. Selznick noted, "I am still a little uncertain about the man, but I feel, in spite of his enormous ears and bad chin line, that his charm is so tremendous that it comes through even in this wretched test."

t he charm was only part of it. It was the triumph of style. Astaire came to define the New Man of the American Century. He used all the old-world types—those stuffed-shirt, humorless Victorian aristocrats, cardboard operetta counts, posturing Russian dukes, South American millionaires, and European playboys—for his film foils, carving out a new romantic image that was distinctly New World American. His revolution might have seemed relatively mild (in the way he woke up the old, fossilized gentlemen's club members at the beginning of *Top Hat*) but it was a mold-breaking declaration. Americans had, after all, invented popular culture, and Astaire epitomized everything for which it stood. He combined ballet, jazz, tap, and ballroom dancing with a seemingly effortless verve, a style that hid the effort in the details and nuances. It was a guise, a studied nonchalance that seemed light and clean and crisp. He was in fact just the opposite: a ceaseless perfectionist. He practiced his routines over and over, causing Rogers's feet to bleed during the endless rehearsals. It was meant to look casual and improvised, like the best spontaneously created jazz performances. It gave us the comforting impression that it was natural, and that talent was both God-given and perfectible, rather than carried by hereditary bloodlines. This was an important aspect of Astaire's modernity.

Clothes came to be a telling symbol of this social change. The whole history of men's clothes in the twentieth century is about comfort and democratic casualness. Since the end of the nineteenth century, there had been a constant movement of sports clothes infiltrating business and formal wardrobes. But for separate jackets and trousers to replace suits, for people to accept the more casual outfit, the sportier clothes had to retain the authority of the more dignified uniform. Astaire had the talent, simply put, to construct a new model for male nonchalance, and everyone from Giorgio Armani and Ralph Lauren to the latest Italian designers has learned more than a thing or two from him. His blend of urban English shape with casual American style—emphasized in the 1941 film *Second Chorus*, where he's on a college campus for the first half of the film and in the city for the second half—typifies American dress to this day. It was Astaire's approach, the idea that talent will triumph, that made it all possible.

i t was a social rebellion of talent and style. But then, all rebellions call for a change of style. The dandy as a social phenomenon had become, during the first years of the nineteenth century, something of a hero and arbiter of an age in transition; it was a turbulent period that shook the foundations of aristocracy, produced the Industrial Revolution, and occasioned the rise of the middle class to wealth and prominence. The dandy was the new man making his way into the world by the force of his style, that coinage of his own minting. As literary historian Ellen Moers points out in her study *The Dandy*, "When such

solid values as wealth and birth are upset, ephemera such as style and pose are called upon to justify the stratification of society." And when you think about it, what are revolutions if not a way to thin out the powdered wigs of the community?

t his idea of the dandy, a personification of a revolution in style, reached an apex in the early decades of the twentieth century, another age of transition occasioned by the great war and economic depression that followed. It was also the so-called golden age of tailored men's clothing that many designers continue to cling to as a source of inspiration. This revolution easily and quickly disseminated because of the new forms of mass popular entertainment: films, radio, fashion magazines, vaudeville, and recordings. The New Man used these tools to speak to the world of shifting values, tremendous financial upheaval, and considerable social unrest. The emphasis on this unsteady scene, and its relationship to the dandy and clothes, was not lost on popular culture. In a 1934 issue, *Esquire* magazine advised its readers to dress up in a new Savile Row style suit, reasoning that it was the best way to dress "if you are so sure of yourself under the New Deal that you are unafraid of offering a striking similarity to a socialist cartoon's conception of a capitalist. Since a good appearance is about all that is left to the capitalist anyway, why not go ahead and enjoy it?"

In the 1920s and 1930s, the vision of the New Man could be seen across the whole of the American entertainment spectrum. It was America's most visible export. There was the rise of crooning, a casual approach to music based on the invention of the microphone, and passed on from Rudy Vallee to Bing Crosby

to Frank Sinatra. In films the New Man appeared in the realistic acting styles of Jimmy Cagney, Humphrey Bogart, and Gary Cooper. He could also be spotted in the improvisational jazz music and dance that came out of the Harlem Renaissance, and the suave styles of Louis Armstrong and Duke Ellington.

but it was Astaire who combined them all. He embodied the idea of the American dandy in those clamorous, glamorous years between the wars, when so many barriers came down. He became a hero whose weapon was style. He taught the Prince of Wales how to dance and introduced the songs of Irving Berlin, the Gershwins, and Cole Porter. It was Astaire who mixed and incorporated the innovative showmanship of the America's George M. Cohan and Bill "Bojangles" Robinson, along with Britain's Jack Buchanan and Noel Coward. It was Astaire who saved the RKO studio from bankruptcy in the 1930s. Not only did he determine the nature of musical comedy for several generations, he was also the one who introduced a new style of dress and deportment to the world. In his early films, many character foils show that Astaire is the New Man. In *Top Hat* (1935), Erik Rhodes, as the florid Alberto Beddini, is perfection: stiff, pompous, and grand of gesture, he awkwardly struts across the stage. Meanwhile, nimble Jerry Travers (even Astaire's characters' names reflect a casual counterpoint: in *Roberta,* his name was Huckleberry Haines, which is about as American as you can get) literally dances circles around him. The "Isn't It a Lovely Day?" dance routine with Ginger Rogers shows Astaire dressed in the style he would make

famous: soft-shouldered tweed sports jacket, button-down shirt, bold striped tie, easy-cut gray flannels, silk paisley pocket square, and suede shoes. It's an extraordinarily contemporary approach to nonchalant elegance, a look Ralph Lauren and a dozen other designers still rely on more than six decades later. Astaire introduced a new style of dress that broke step with the spats, celluloid collars, and homburgs worn by aristocratic European-molded father-figure heroes. No wonder, as Astaire's biographer Bob Thomas notes, Fascist censors refused to have a film like *The Gay Divorcee* shown in Italy: "the character of the cuckolded Tonetti...was 'offensive to Italian prestige'."

t he model of the European leading man was based on ideals of remote awe and dignity. He was a man of breeding, high culture, and inherited wealth. The New Men—the Astaires, Crosbys, and Coopers—made all that formality and grand gesturing seem overblown and rigid, too artificial and contrived for democratic tastes. Natural vitality was the keynote to New World poise.

At one point in his early film career—*Shall We Dance* (1937)— Astaire actually played both hero and foil roles himself. Disguised as the Russian ballet star Petrov, he really is "Pete P. Peters from Philadelphia, PA." Edward Everett Horton, as his manager, hisses, "Sacrilege!" when he sees Astaire has coolly flaunted convention by putting taps on his ballet slippers. A scene later, Ginger Rogers dismisses Astaire-as-Petrov, saying, "As long as I live, I hope I never see another hand-kissing heel-clicker again," and we laugh at the send-up and nod our democratic approval. As Edward Gallafent notes in his book *Rogers and Astaire*, Astaire was such a powerful presence, everybody gave him the right to make fun of

other figures of authority. The sentiment is echoed again and again. The film *You Were Never Lovelier* (1942), to name but one example, is based on the premise that Astaire is completely ordinary: "I'm a plain, ordinary guy from Omaha, Nebraska," he says. Then he proceeds to sing and dance the "I'm Old-Fashioned" number and win the heart of Rita Hayworth, despite competition from South American playboys, and despite her aristocratic father (played to the max of stiff arrogance by Adolph Menjou, who is meant to represent the privileged classes of South America).

I n the Astaire-Rogers films, the wealthy, stiff-suited, aristocratic European of higher culture and breeding always loses out to the Pete Peters or the Huck Haines. The New World has a fresh approach to the romantic hero: vitality, urbanity, charm, and natural talent—all carried off in an effortless manner. Astaire was the democratic ideal: a classless aristocrat. It was an ideal based on natural instinct, one without guile or deception, that held sway until it was taken even further by the prole hero of the 1950s in the form of James Dean and Marlon Brando. These actors embodied the American ideal and expanded upon it, making it an obsession to reveal their inner selves. But American "cool" started with Astaire's fine art of understatement.

Astaire's first on-camera dance routine is in *Dancing Lady* (1933), when he's asked to rehearse a number with Joan Crawford. The dancing is rather basic here, but his clothes signal a new era of purposeful casualness: a soft flannel single-breasted suit—worn here with two-tone spectator shoes and a

turtleneck! The combination of a business suit with a casual sweater rather than a shirt and tie struck a wonderful note of nonchalance. Later that year, in *Flying Down to Rio,* one gets the full treatment as Astaire and Rogers sit on the pavement after the former has been thrown out of restaurant. The muted plaid suit worn by Astaire was called a "race track suit"; it is slightly more casual than a business suit but not unusual. But how Astaire accessories the suit is what sets him apart: a soft button-down shirt and pale woven tie, a silk pocket square, and bright horizontally striped hose and white buck shoes. This look is a mélange of the classic and the sporty, an American invention of mixing genres that symbolizes a modern lifestyle. And Astaire is its greatest advocate and model.

There was also a simple reason for the casualness of his wardrobe: as a dancer, his clothes had to be comfortable and well cut. They had to move with him, and so at his tailor's he'd expand a fitting into an improvised dance routine, flinging his arms and legs about to make sure the sleeves didn't bind or the crotch crunch. If you're a dancer, you can't have your body go one way and your suit another. The suit had to follow him.

S oftness and comfort. Jackets had to be roomy enough not to be constricting, but still hold their shape. Trousers had to be cut on the full side, but not sloppy or billowy. A new aesthetic evolved, and so did the relationship between clothes and attitude, style and demeanor. Astaire, an anti-Victorian, had discovered that stiffness and dignity could be replaced by natural grace. During the Depression, this aesthetic became the Mid-Atlantic model: a blend of Savile Row with

Princeton. Astaire saw the great virtues of the English drape-cut coat, but rejected the high-waisted trousers cut for braces. He popularized the soft-rolled button-down shirt worn on Ivy League campuses, along with patterned hose and suede shoes, and wore them with a double-breasted suit.

●

in the 1930s, suspenders were the accepted way of holding up trousers. But Astaire would have none of it. He opted for self-supporting waistbands or the prep school trick of twisting a scarf or necktie around the waist. And while he wasn't against wearing a tie clip or a collar bar, jewelry really wasn't his thing. Maybe jewelry was too obvious and blatant for him, both too arriviste and too aristocratic. Or maybe he just had the sense to know that it's damned hard to wear jewelry nonchalantly.
The other New Men—Hemingway and Scott Fitzgerald, Ellington and Berlin, Douglas Fairbanks Senior and Junior, Bing Crosby, Jimmy Cagney, and Gary Cooper—all shrugged off the formality of Victorian constrictions on artistic expression, but it was Astaire, dancing the stiff and contrived aristos off the stage, who became our model of natural elegance. Astaire's style matched his dancing. He was light and nonchalant, cool and casual. His performances were totally unlike the hyper-dignity, histrionic wrist acting and operatic arias of old-world performances. Astaire mixed his dance styles the way he mixed his dress styles: with a spontaneous exuberance in which the hard work was well hidden within the detail and subtlety. His incredible finesse produced an effect that was meant to look spontaneous and natural.

In *Swing Time* (1936), when the dance studio proprietor, consummately played by Eric Blore, asks Lucky Garnett (Astaire) what sort of dance instruction he wants—"tap," "ballroom," or "aesthetic"—Lucky casually says, "If it's all the same to you, I'll take a little of each." Which is exactly what he did. It could have been the motto for the American experience.

Holiday Inn (1942) perhaps best embodies this American style: it brings together Bing Crosby, Fred Astaire, and Irving Berlin, who, in the words of John Lahr, "hymned the joys of the modern republic." The film shows how established the American style had become. As Bing Crosby did with song, Astaire perfected a style of nonchalance and seeming ease. Crosby's approach was based on a cool attitude and delivery, a lilting insouciance. The invention of the electric microphone allowed him to croon, rather than blast out in operatic fashion. It was a style grounded in tone and nuance, rather than theatrics and volume. The film camera did the same thing for Astaire: it allowed him to perfect the casual gesture, to replace heavy, blatant formality with lightness and facility. What emerged was a style of nuance and subtlety, rather than grand gestures and heavy dramatics.

t he lesson his early films teach is that cardboard continental counts don't have the monopoly on class, or even the edge for that matter, and that natural style is what makes for real sophistication and true aristocracy of character. Astaire's early films are all about the rise of the democratic view that charm and style naturally triumph over breeding. Time and time again in the Astaire-Rogers films, nonchalance defeats formality, heritage succumbs to natural finesse, vitality overcomes

rigid ceremony, propriety is bested by humor, and ritual dignity by legitimate naiveté. High culture—opera, ballet, classical music, and even the clothes and deportment—is replaced by the popular culture of jazz and sports clothes. It is only when he is forced into an artificial pose that difficulties arise for Astaire. When he is true to himself, he triumphs.

The popular culture of Astaire's heyday was freer and looser, more improvisational and more accessible. We knew who were the rightful King (Joseph Oliver), Count (William Basie), and Duke (Edward K. Ellington); "All God's children got swing" was an anthem in which privilege had been replaced by style.

astaire's was the triumph of pure style. His weak, warbling voice and his casual delivery were no obstacle to his interpretations of great songs. His thinning hair and slight build were not an impediment to making him a style icon. He could wear the uniform of the upper class when the need called for it, but it's ironic that the man some associated with the top hat and tails is really the one who popularized the sports jacket and soft lounge suit.

Seventy years after *Flying Down to Rio*, Astaire's rules still apply. A good wardrobe is made up of the tried and true classics: soft flannel suits in dark blue or gray solids and chalk stripes; neat patterned tweed sports jackets and navy blazers; tailored clothes that are soft, lightweight, and easily cut, but with some shape. A blend of the Savile Row and American Ivy League, jackets were pliant, roomy enough not to constrict, but would still hold their shape. In other words, the small-shouldered, soft-chested, international sartorial look that's worn today.

Astaire wore white ties and tails as though they were pajamas, and a tuxedo as though it were a part of his everyday routine, rather than borrowed from some Prussian general. It wasn't supposed to look perfect; it was supposed to look natural. It worked then, and it works now. It's what genius and style are all about.

"He became a hero whose weapon was style."

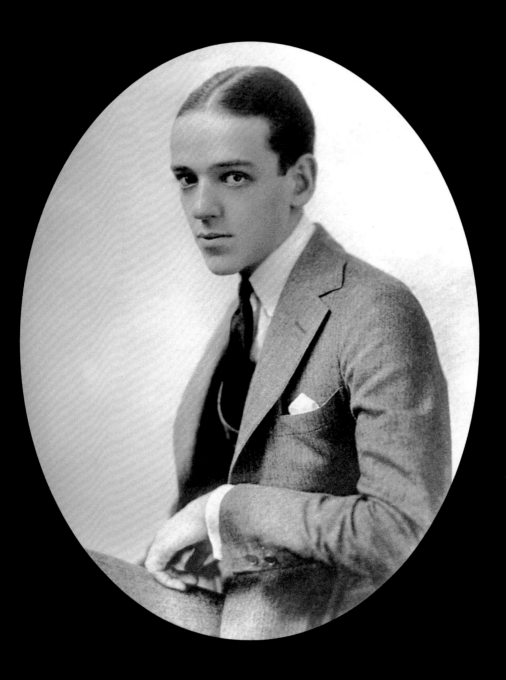

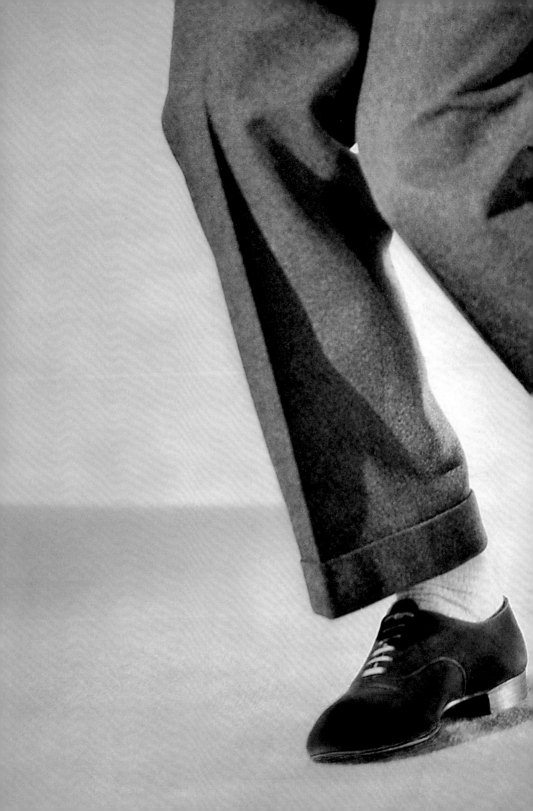

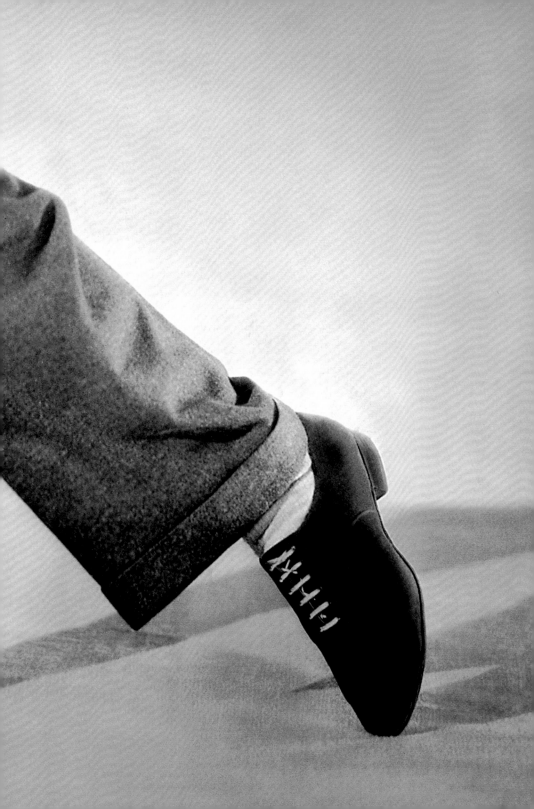

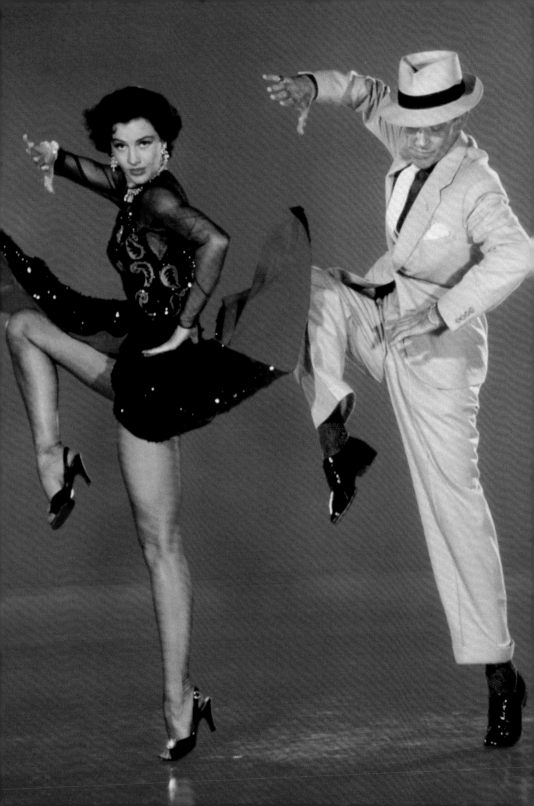

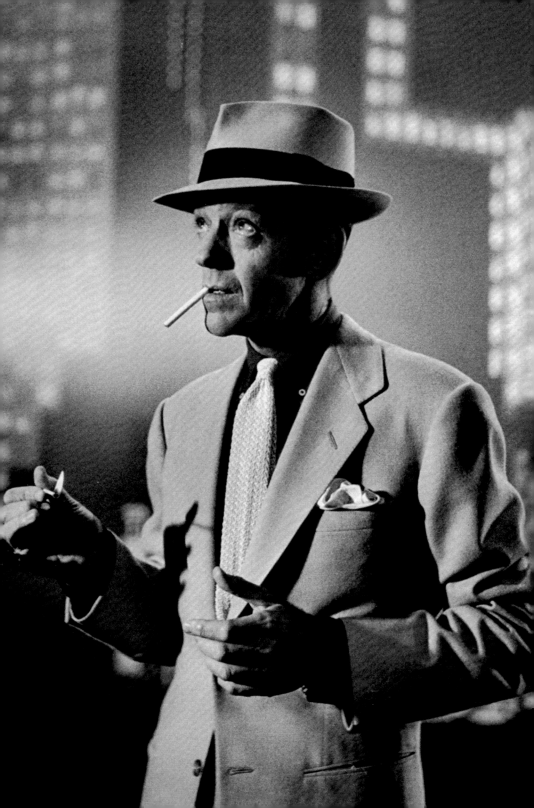

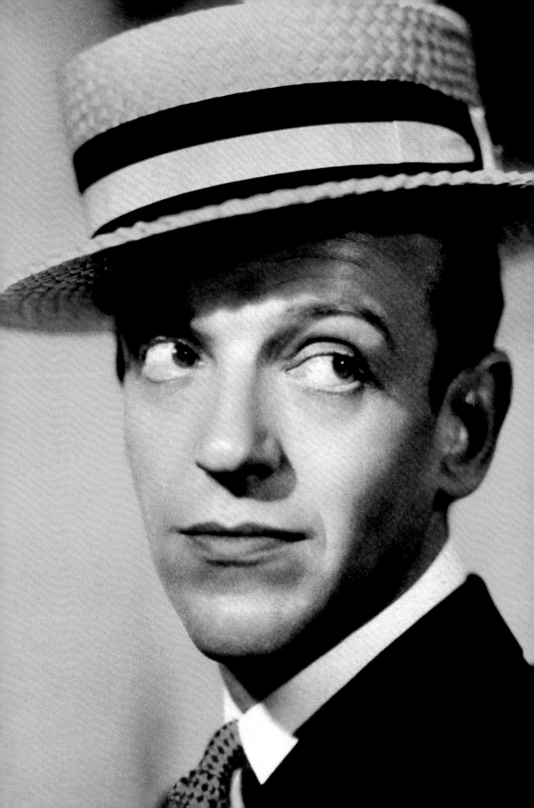

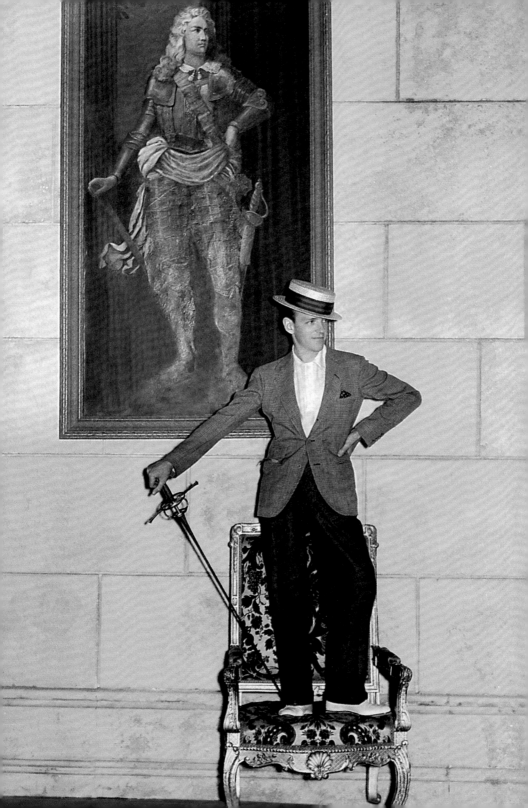

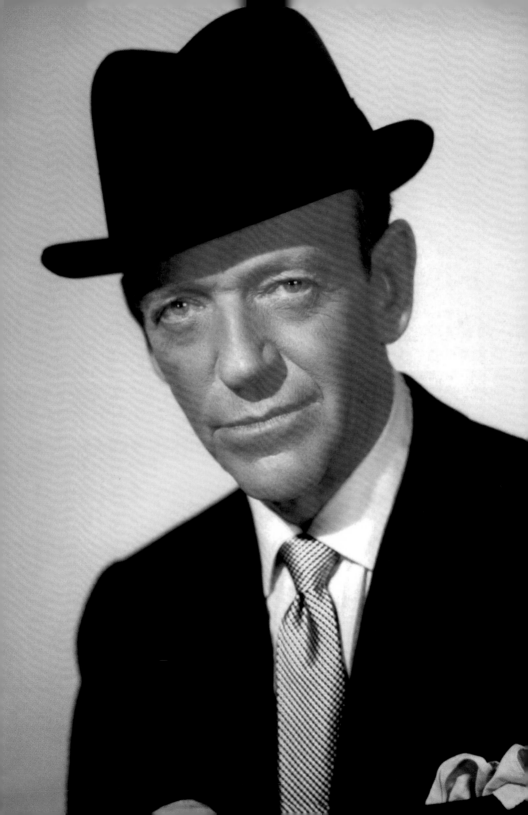

"American 'cool' started with Astaire's fine art of understatement."

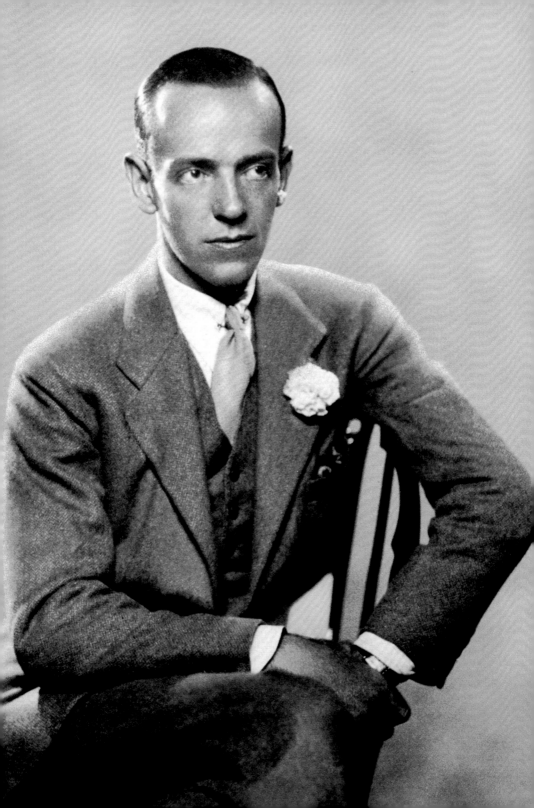

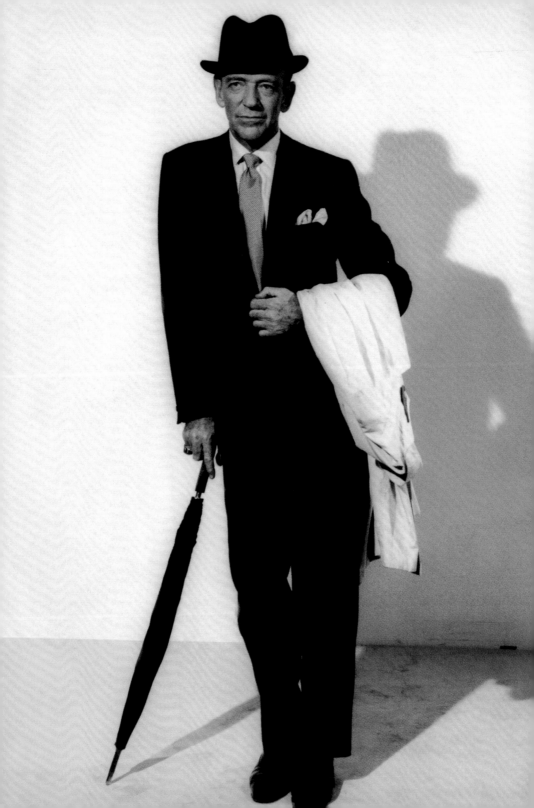

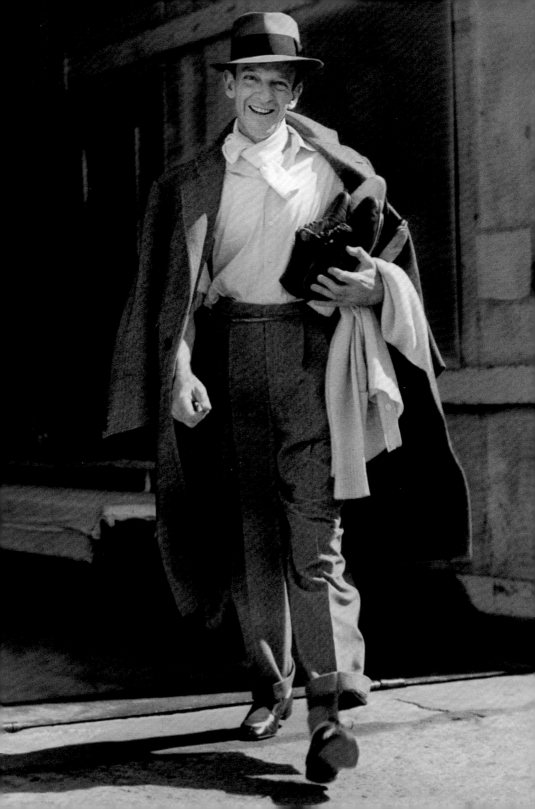

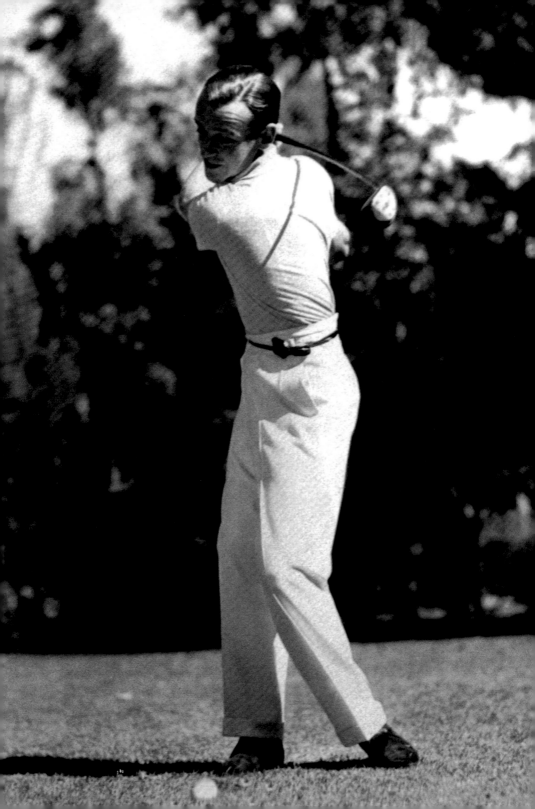

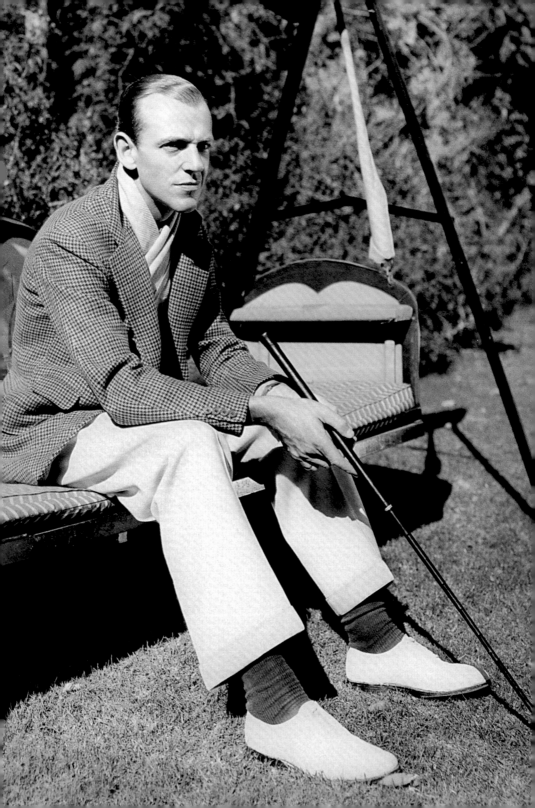

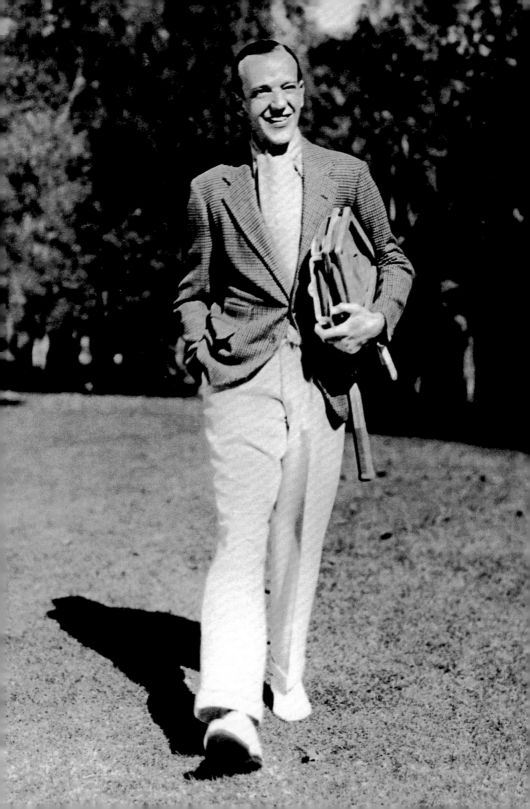

"The New World has a fresh approach to the romantic hero: vitality, urbanity, charm, and natural talent—all carried off in an effortless manner. Astaire was the democratic ideal: a classless aristocrat."

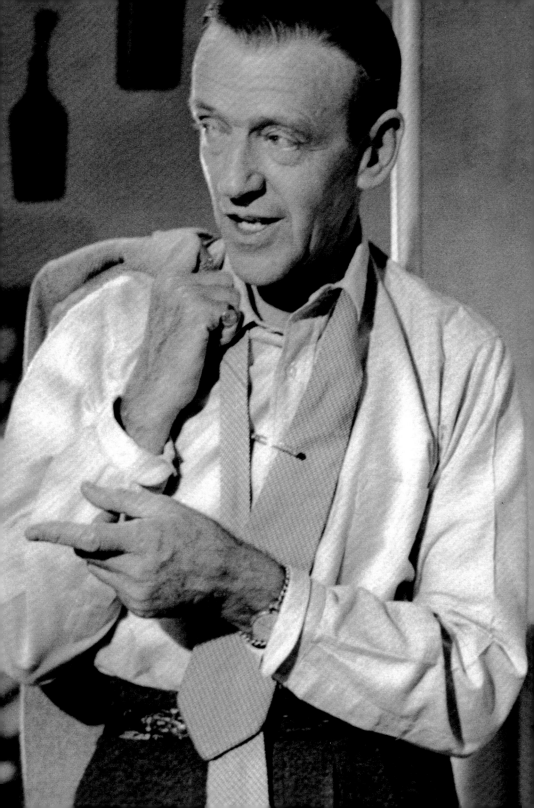

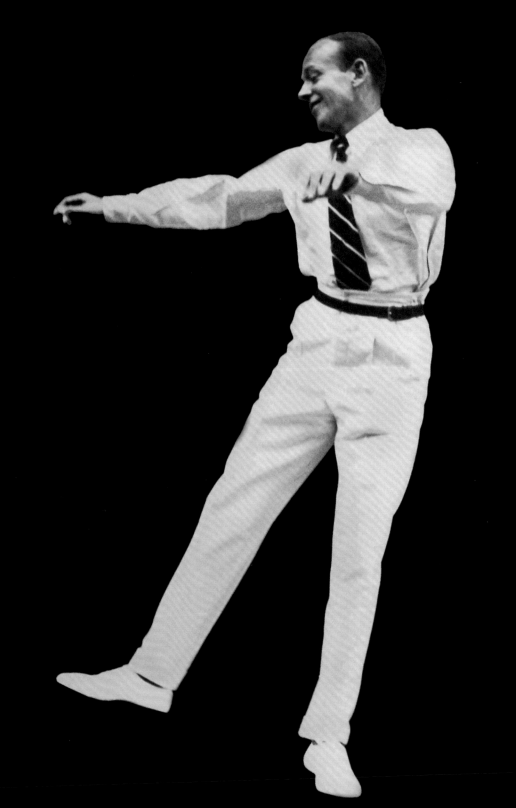

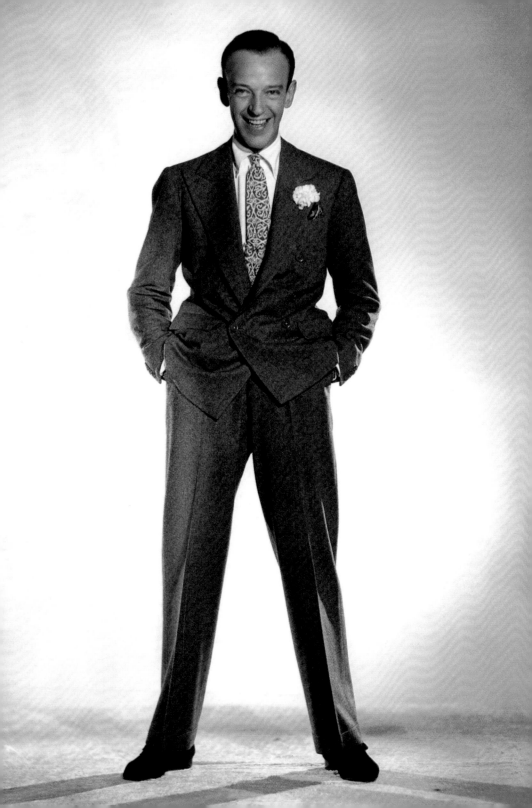

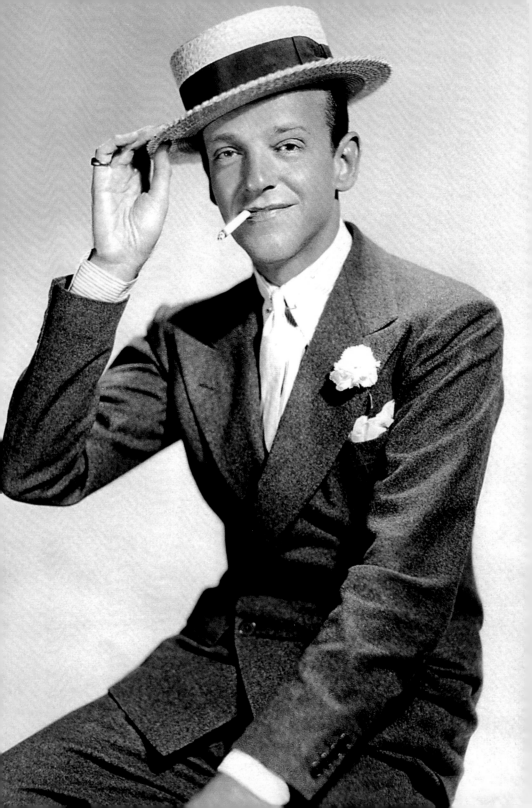

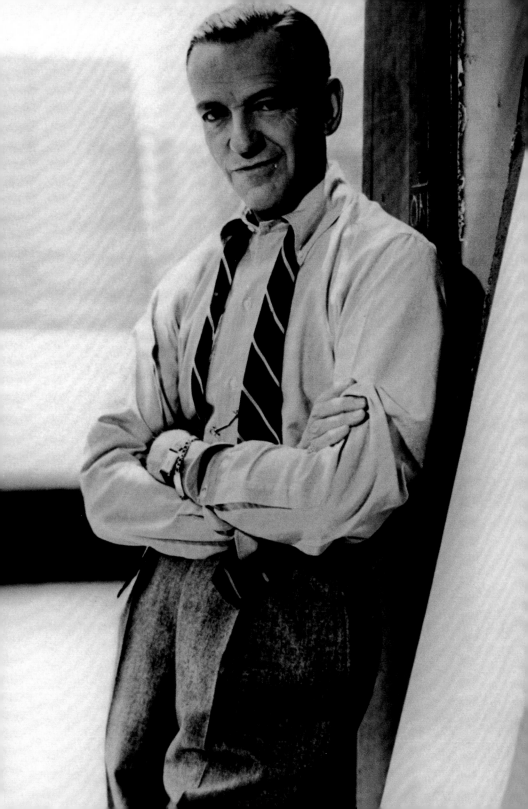

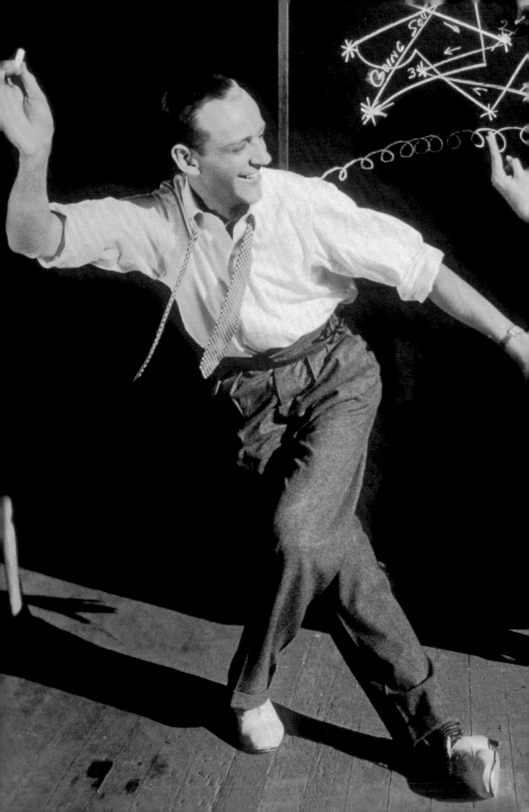

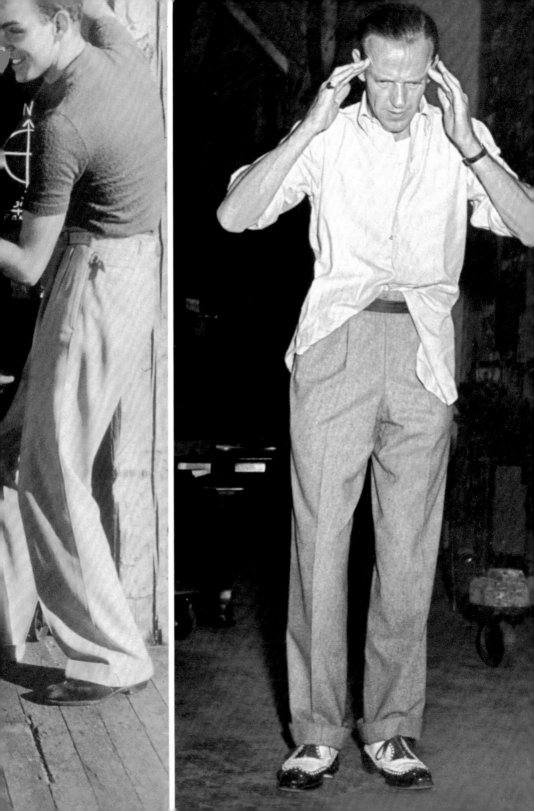

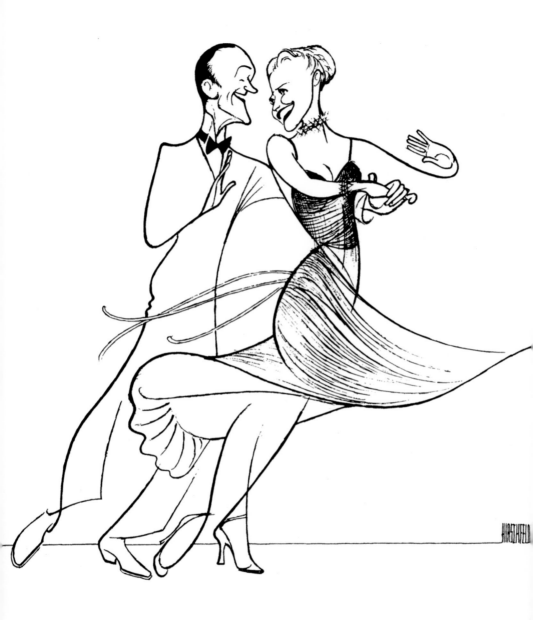

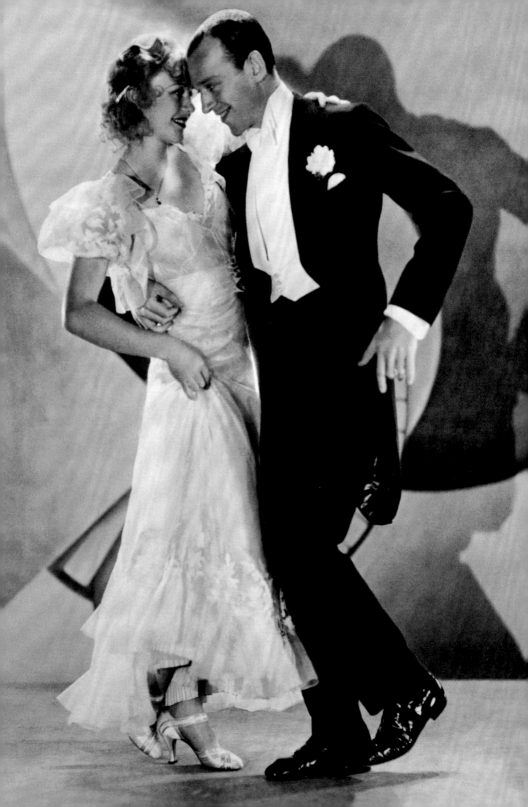

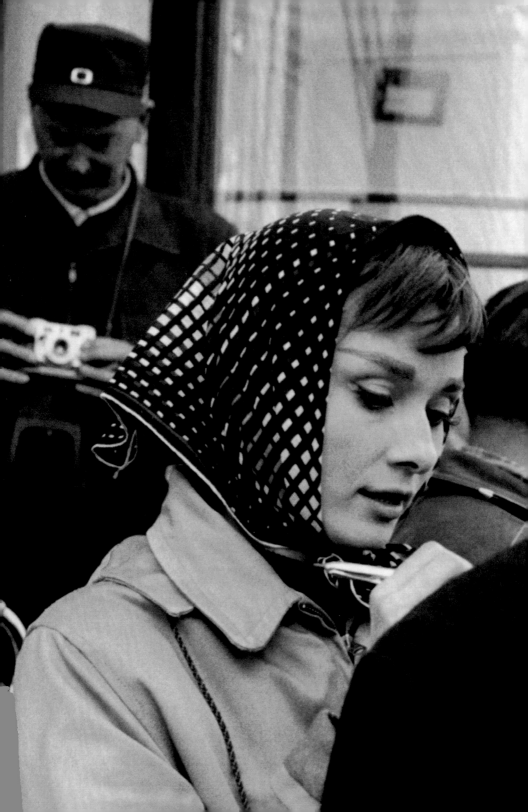

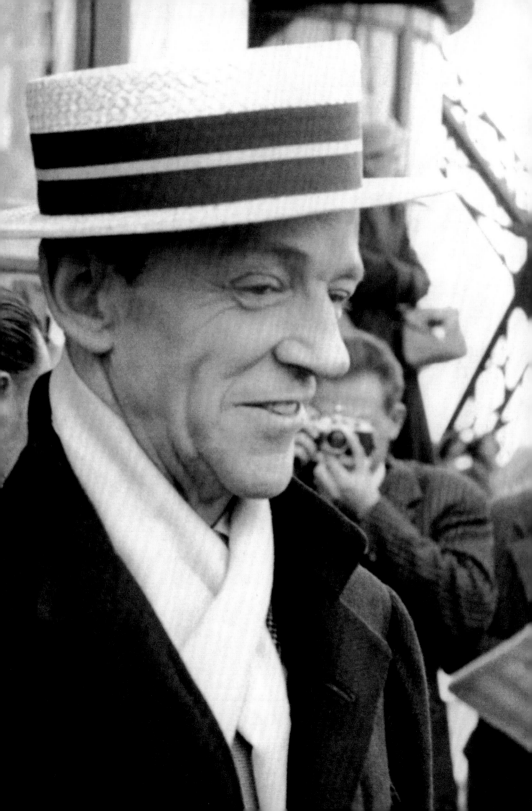

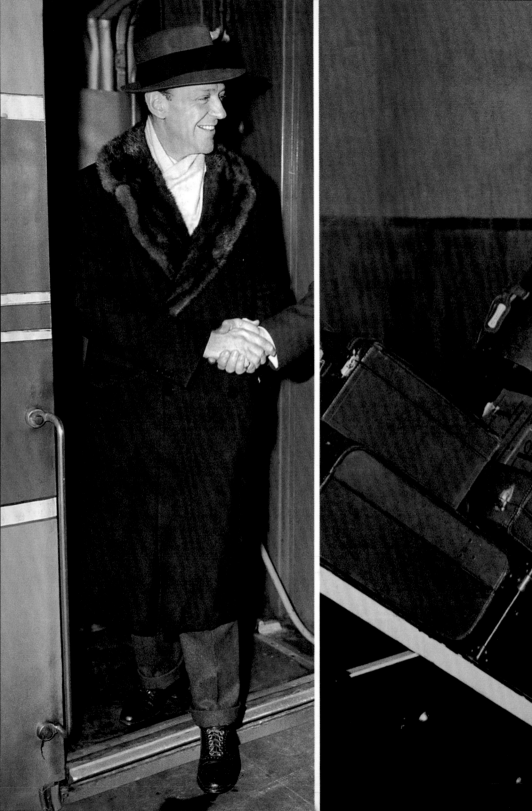

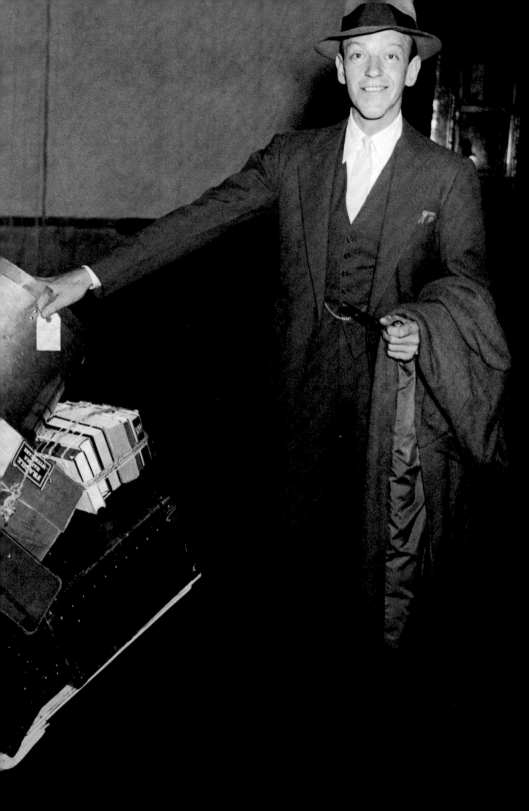

"Astaire had the talent, simply put, to construct a new model for male nonchalance, and everyone from Giorgio Armani and Ralph Lauren to the latest Italian designers has learned more than a thing or two from him."

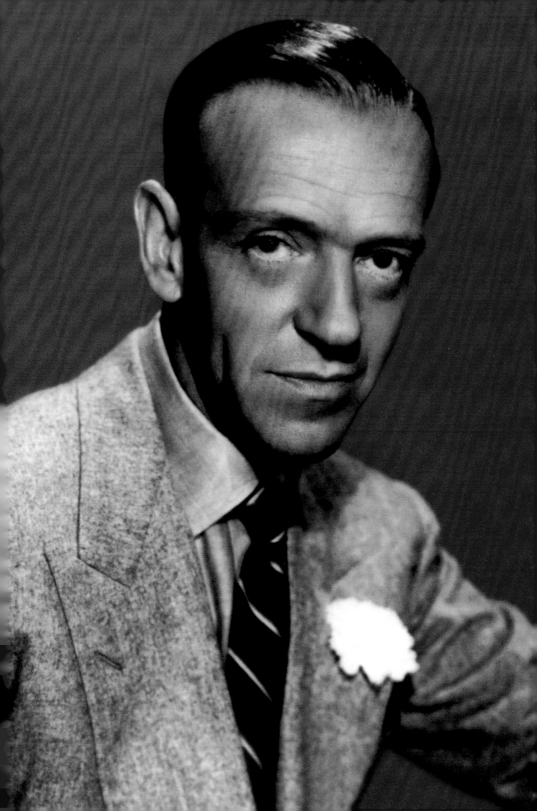

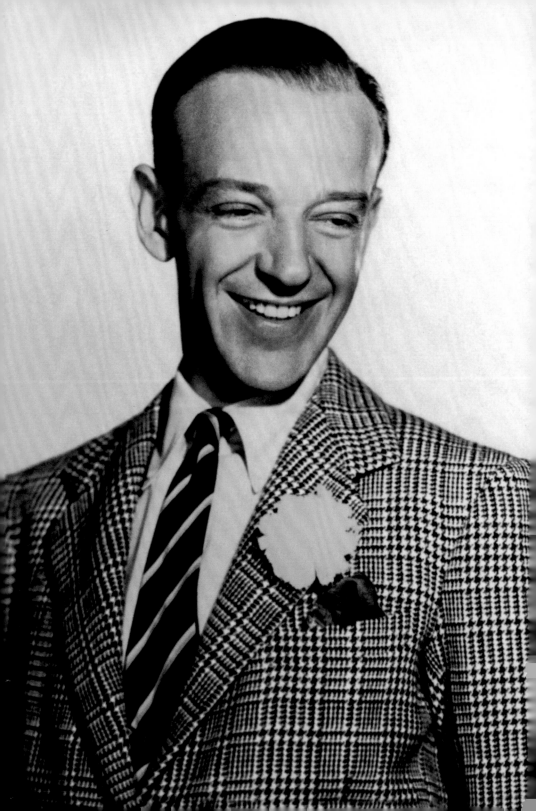

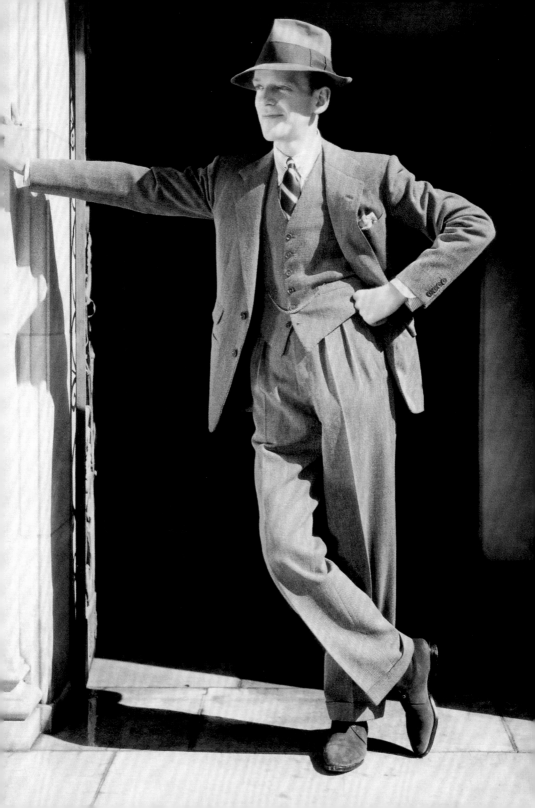

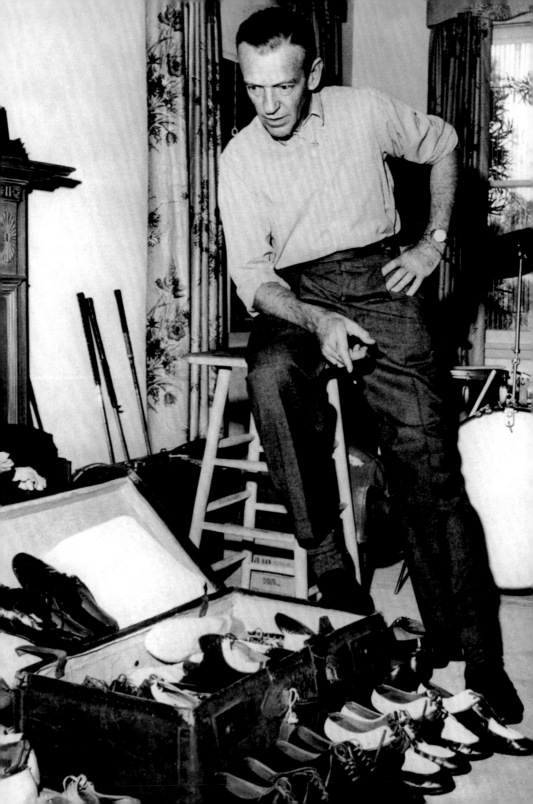

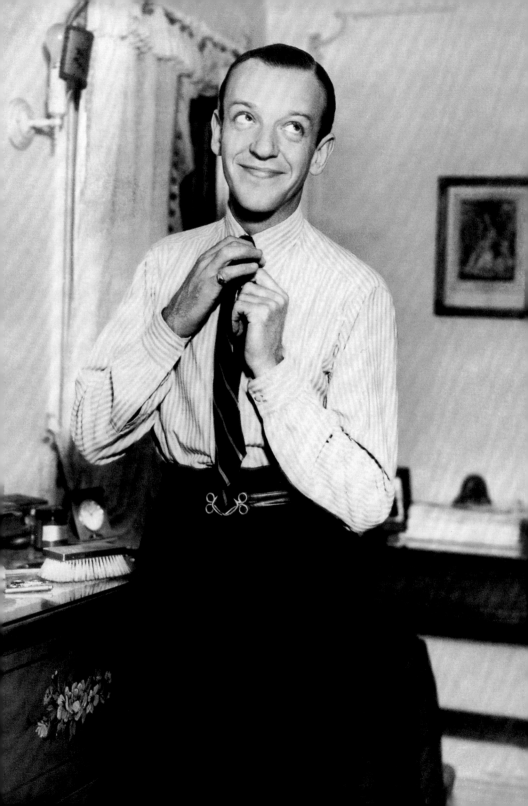

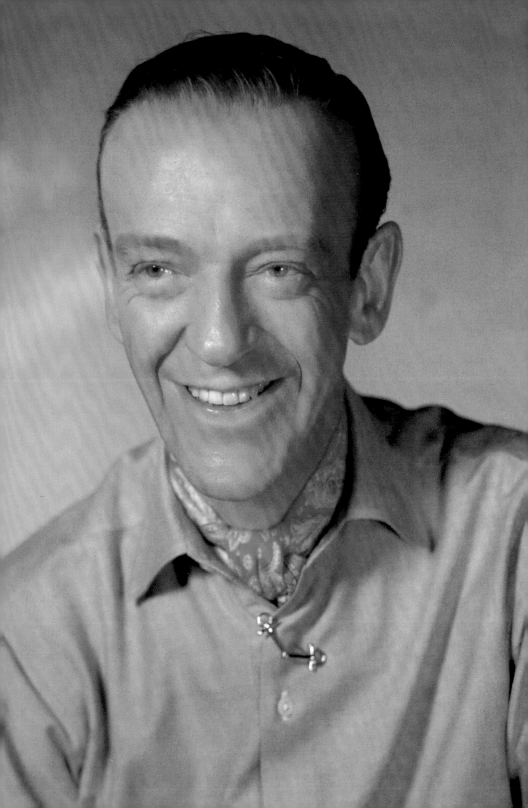

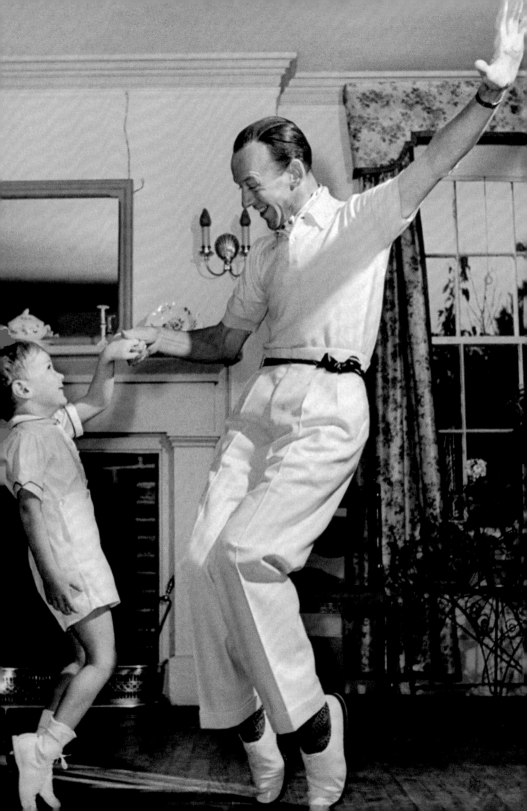

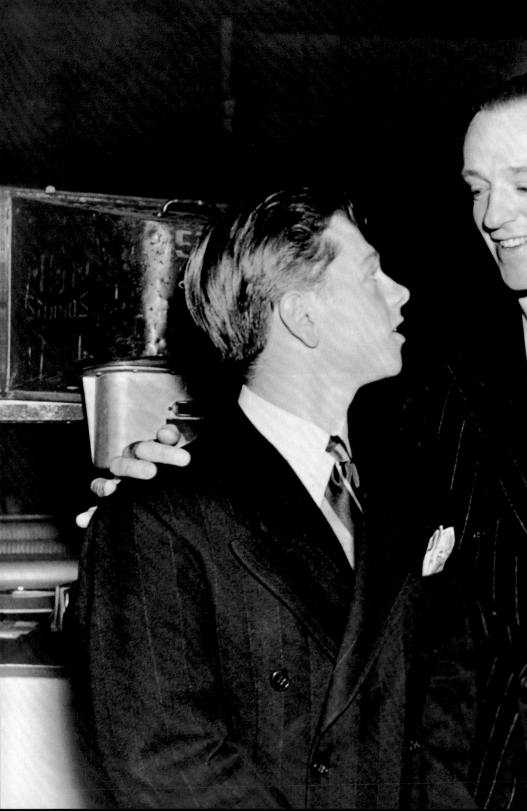

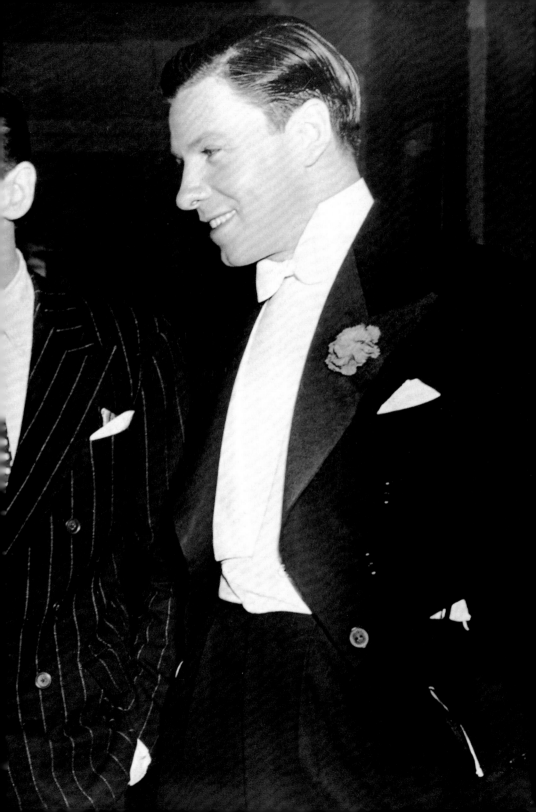

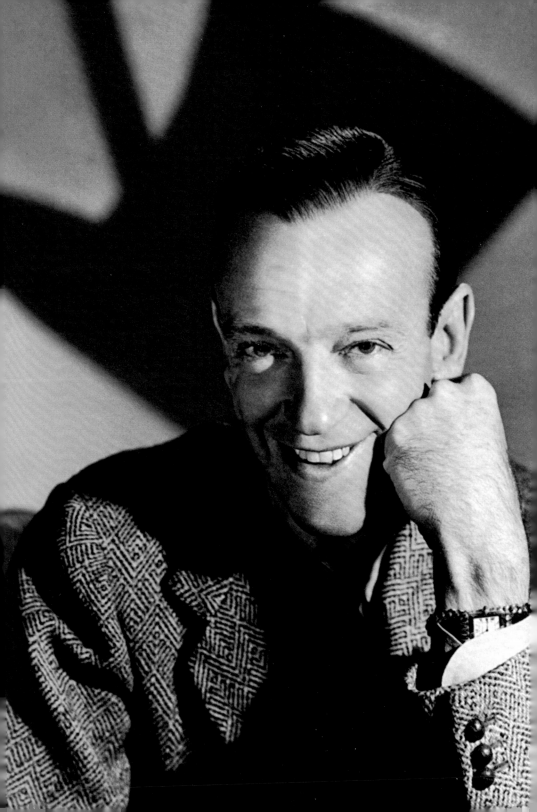

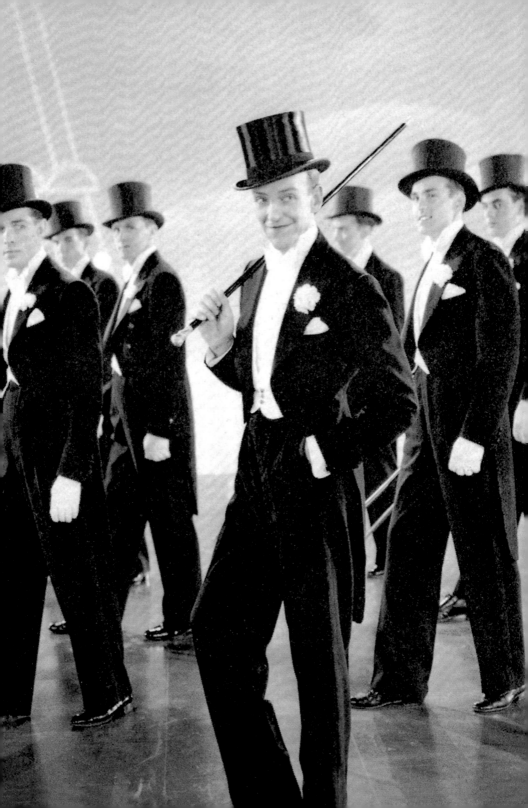

"Astaire mixed his dance styles the way he mixed his dress styles: with a spontaneous exuberance in which the hard work was well hidden within the detail and subtlety."

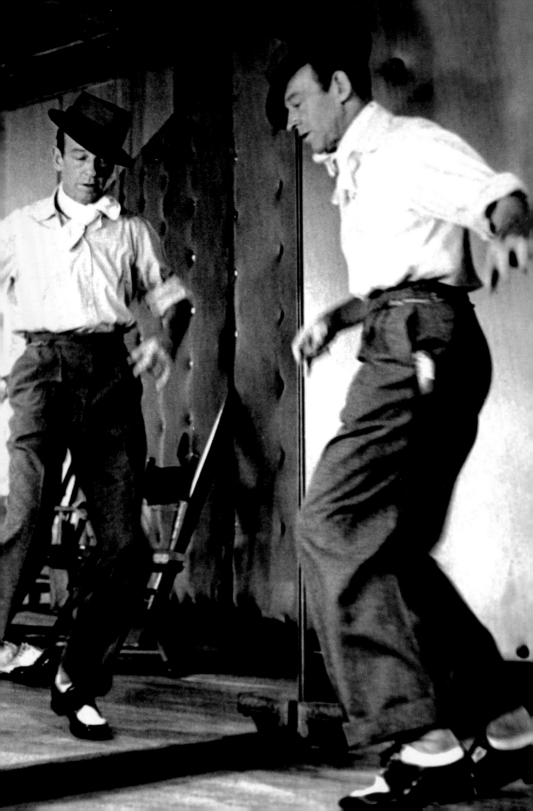

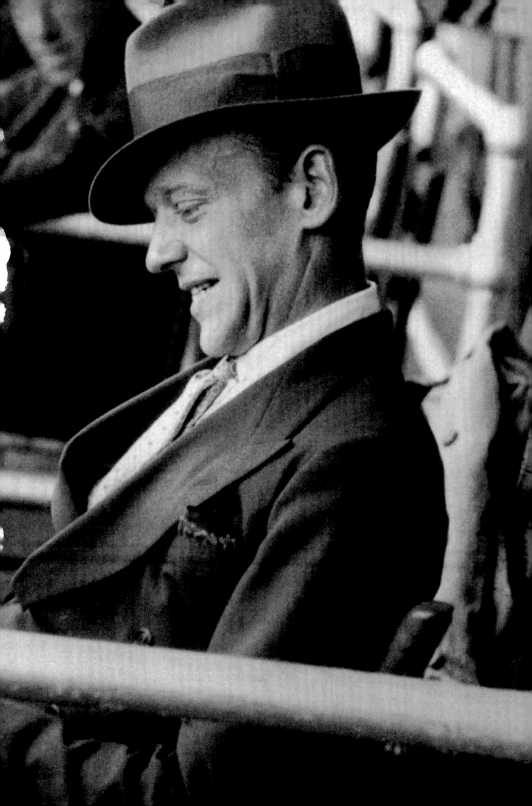

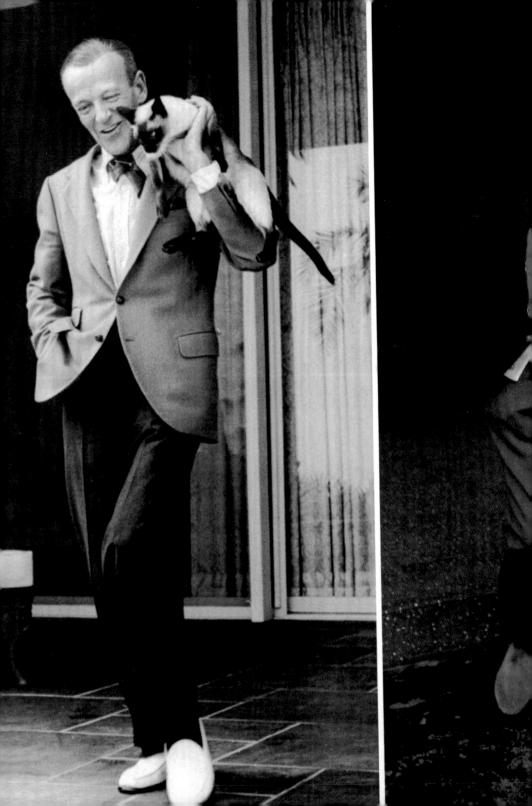

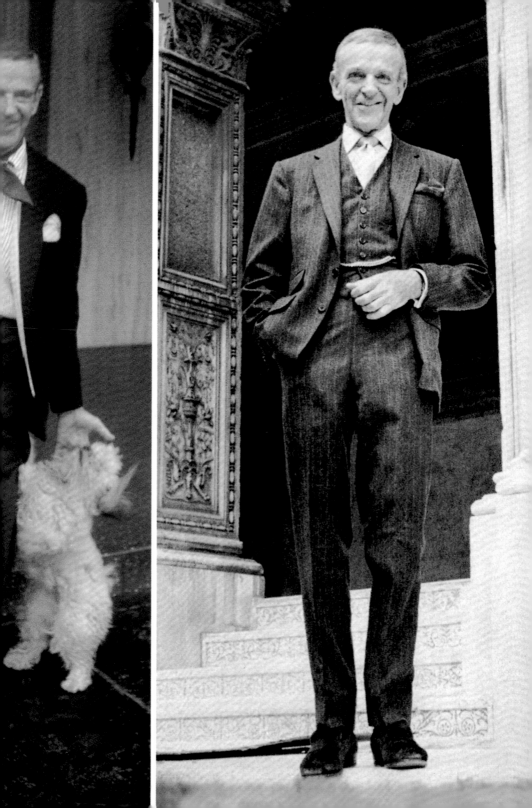

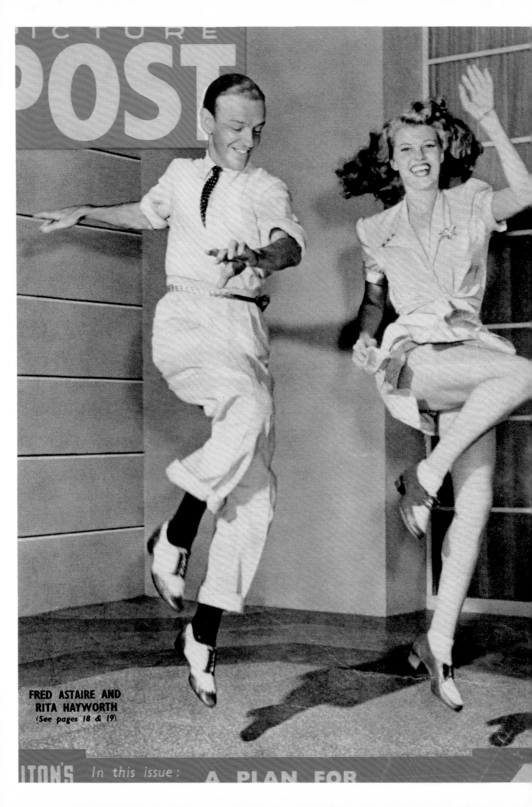

PICTURE
POST

FRED ASTAIRE AND
RITA HAYWORTH
(See pages 18 & 19)

ITON'S In this issue : A PLAN FOR

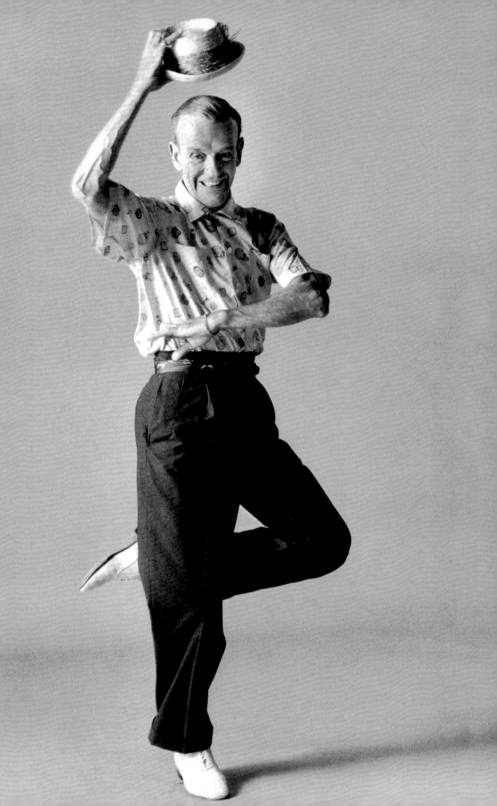

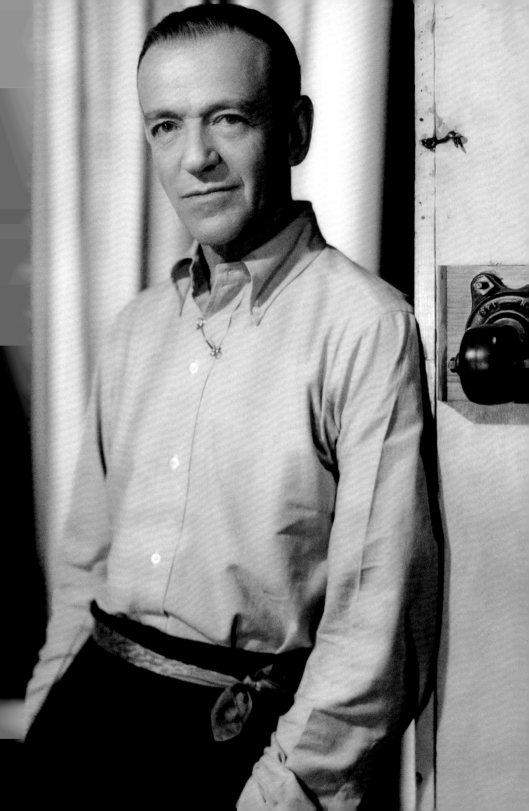

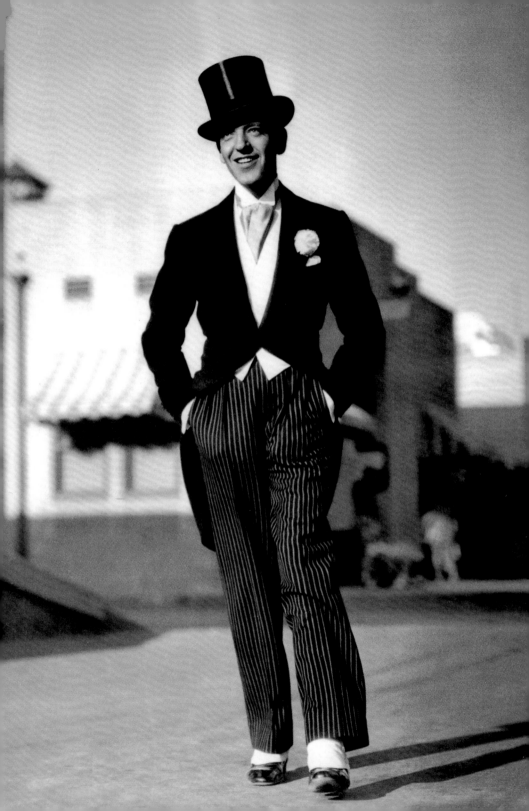

Chronology

1897: On September 10, Adele Austerlitz, Fred's sister, is born in Omaha, Nebraska, to Frederic and Johanna Geilus Austerlitz.

1899: On May 10, Fred Austerlitz is born in Omaha.

1917: On November 28, Fred and Adele appear in their first Broadway musical, *Over the Top*. They change their surname to Astaire.

1923: On May 30, the Astaires open in their first London musical, *Stop Flirting*. During the next eight years, they become the toast of Broadway and of London's West End.

1931: On June 3, *The Band Wagon* opens on Broadway. It is Fred and Adele's last play together.
In May 1932, Adele marries Charles Cavendish, the second son of the duke of Devonshire, and retires from the stage.

1933: On July 12, Fred Astaire marries socialite Phyllis Livingston Potter and the couple moves from New York to Hollywood.
On December 2, Astaire's first film, *Dancing Lady*, is released. He has a minor role; the stars are Clark Gable and Joan Crawford.
On December 20, Astaire's first film with Ginger Rogers, *Flying Down to Rio*, opens. Both have secondary roles to the leads, Dolores del Rio and Gene Raymond.

1934: On October 3, *The Gay Divorcee* is released, Fred and Ginger's first starring roles together. This huge success is followed by *Roberta* and *Top Hat* (1935), *Follow the Fleet* and *Swing Time* (1936), and *Shall We Dance* (1937). They are now the most famous dancers in Hollywood.

1937: On November 20, *A Damsel in Distress* is released, with co-star Joan Fontaine.

1938: On August 30, the Astaire-Rogers partnership resumes with *Carefree*, followed by *The Story of Vernon and Irene Castle* (1939).

1940: On February 14, *Broadway Melody of 1940* is released, co-starring dancer Eleanor Powell. This is the first of a string of musicals with new partners: *Second Chorus* (with Paulette Goddard, 1940), *You'll Never Get Rich* (with Rita Hayworth, 1941), *Holiday Inn* (with Bing Crosby, 1942), *You Were Never Lovelier* (with Rita Hayworth, 1942), and *The Sky's the Limit* (with Joan Leslie, 1943) are the most memorable.

1946: On September 26, Astaire co-stars again with Bing Crosby in *Blue Skies*.

1948: On June 1, Astaire stars with Judy Garland in *Easter Parade*.

1949: On April 11, *The Barkleys of Broadway*, the last Astaire-Rogers film, is released.

1953: On July 7, after four mediocre films, Astaire makes a triumphant comeback with Cyd Charisse in *The Band Wagon*; he follows it up with three more great films: *Daddy*

Long Legs (with Leslie Carron, 1955), *Funny Face* (with Audrey Hepburn, 1957), and *Silk Stockings* (with Cyd Charisse, 1957).

1954: On September 13, Phyllis Astaire dies.

1958: On October 17, Astaire begins a stylish series of TV appearances, *An Evening with Fred Astaire.* Three others follow and receive great critical acclaim.

1959: On December 2, Astaire appears in *On the Beach,* his first dramatic role.

1968: On October 9, *Finian's Rainbow* is released, Astaire's last musical.

1974: On June 15, the anthology *That's Entertainment* is released, occasioning a retrospective interest in the Hollywood musical. Three other installments follow.

1980: In June 24, Fred Astaire marries Robyn Smith.

1981: On January 25, Adele Astaire dies.
On December 15, Fred Astaire accepts the Lifetime Achievement Award of the American Film Institute.

1987: On June 22, Fred Astaire dies in Los Angeles.

The greatest dancer of the twentieth century at his ease. And still the epitome of elegance at 87.
© Photo Richard Schulman/Corbis.

Fred Astaire Style

The young Astaire contemplates his future, circa 1920. The natural-shouldered suit coat proclaims his early commitment to style and comfort. © Photofest.

The famous dancing feet wearing the brown suede oxfords and fancy lacing that Astaire favored. Accompanied, of course, by bright hosiery and the trademark gray flannel trousers. © RKO Radio Pictures, Inc/Photofest.

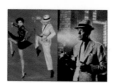

Fred Astaire and Cyd Charisse in The Band Wagon (1953). Arguably Astaire's most beautiful partner, Cyd Charisse brought a balletic quality to their dance routines. © Sunset Boulevard/Corbis Sygma.
Fred Astaire doing a dance parody of a Mickey Spillane scene in The Band Wagon (1953), complete with gangster look (black shirt and white knit tie) and slightly oversized suit in the "drape" style. © John Swope/Time Life Pictures/Getty.

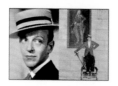

Astaire in Carefree (1938), wearing his jaunty straw boater with the striped regimental silk band. © Rues des Archives/Snap Photo.
A still pose from A Damsel in Distress (1937). Note the elegantly full-cut flannel trousers, and sports jacket with a slight crescent-cut front, low button stance, and high armhole, all of which Astaire designed to aid his dance movement. © Photofest.

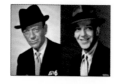

Portrait of Fred Astaire. © Collection Christophe L.
The master of casual elegance in his uniform: understated suit, colorful silk pocket square, soft-roll oxford button-down shirt, wedding necktie, and felt porkpie hat with broad grosgrain band, circa 1940s. © Photofest.

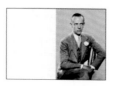

Astaire in the late 1920s, probably around the time of the George and Ira Gershwin hit musical Funny Face, in which he and his sister, Adele, starred. © Bettmann Archives, New York.

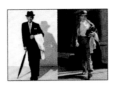

Astaire in an English mode of dress. © Collection Christophe L.
Geared up for rehearsal on a back-lot soundstage, 1940s: extra shoes, sweat towel at neck, trousers rolled. © John Engstead/MPTV.net.

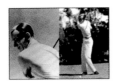

Practicing a favorite sport, 1930s, in lisle polo shirt and gabardine trousers with self-supporting waistband. The silk scarf around the waist is more a point of eccentric style than necessity. © Collection Christophe L.

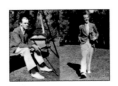

Astaire elegance at home, 1936: Savile Row-cut tweed sports jacket in a district check pattern (note the ticket pocket), white gabardine trousers, white buckskin shoes with rubber soles, and a cashmere scarf as an ascot. © Photofest.
With tennis racquets, 1936. Jacket and trousers by London's famed tailors Anderson & Sheppard. © Courtesy Polo Ralph Lauren.

Astaire rehearsing his first TV special, An Evening with Fred Astaire, September 9, 1958, in Hollywood. At age 59, he doesn't seem to have changed much from his early years in films, except for his dance partners. His new partner is 21-year-old Barrie Chase. The critical response to the show was overwhelming; it set a new standard for TV musicals, and won nine Emmys. © Bettmann/Corbis.

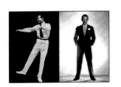

"Our homeward step was just as light as the dancing feet of Astaire / And like an echo far away / A nightingale sang in Berkeley Square." ("A Nightingale Sang in Berkeley Square," Eric Maschwitz). © Photo courtesy Peter Rauch.
Casual refinement in a drape-cut gray flannel double-breasted suit, worn idiosyncratically with a button-down shirt and bold paisley silk tie. Perfectly finished off with a white carnation, late 1930s. © Photofest.

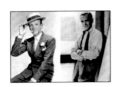

The young man-about-town in the early 1930s. Note the dressy long-point, or pinned collar, a style much favored at the time. This pose shows Astaire's ability to appear elegant, dressy, relaxed, and somewhat sporty, all at the same time. © Photofest.
At nonchalant ease, wearing his favorite-style neckwear, regimental stripes. © Collection Christophe L.

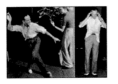

Astaire illustrates a step diagrammed by choreographer Hermes Pan, January 1936. They're both laughing because they simply made up the nonsensical swiggle on the blackboard for the photographer. © Museum of the City of New York/Getty Images.
The pensive genius works out a new routine at a studio rehearsal. Disheveled but wonderfully attired in gray flannels, an oxford buttondown, and spectator lace-ups, with a scarf knotted around his waist. © Bob Landry/Time Life Pictures/Getty Images.

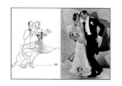

Drawing of Fred Astaire and Ginger Rogers. © Al Hirschfeld.
A classic Astaire-Rogers pose, from their first film together, *Flying Down to Rio* (1933). They had second billing but were an immediate success with moviegoers and critics alike. © Bettmann/Corbis.

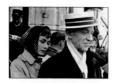

Astaire and Audrey Hepburn on location in Paris for the release of the Paramount musical *Funny Face*, in 1956. This movie was a remake of the play Astaire had staged with his sister, Adele, on Broadway in 1927. © Bert Hardy/Getty Images.

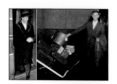

Astaire arrives in Manhattan on March 7, 1947, to open his new venture: the Fred Astaire Dance Studios, Inc. © Photofest.
Astaire arrives at Grand Central Station on June 19, 1934. He had just completed the musical *The Gay Divorcee*, his second film with Ginger Rogers at RKO Radio Pictures. The Astaire-Rogers combination would soon be needed to bring RKO out of bankruptcy. © Bettmann/Corbis.

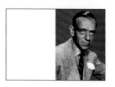

Astaire during the filming of *Blue Skies* in late 1945; the picture is ample evidence of Astaire's timeless style. He could walk down the street today wearing these clothes and be accounted an incredibly well-turned-out man. It is what continues to make him a sartorial inspiration. © Collection Christophe L.

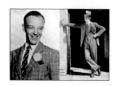

Astaire in the mid-1940s, wearing a beautifully cut Anderson & Sheppard sports jacket in a Shetland tweed Prince of Wales plaid pattern. © Courtesy G. Bruce Boyer.
Astaire on a soundstage shortly after his arrival in Hollywood in 1933. Dressed in an immaculate tweed three-piece town suit, long-point pin-collared dress shirt and striped tie, brown suede chukka boots, and a felt fedora. © Courtesy Peter Rauch.

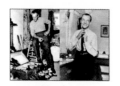

Astaire at home, contemplating his shoe wardrobe. Friends and family said he bought shoes all over the world, and would customarily wear out dozens of pairs during rehearsals for a musical. As can be seen, he had a penchant for two-toned spectators, as well as brown suede. © Collection Christophe L.
Astaire grooming, 1935. Note the fancy belt buckle and monogram on the left shirtsleeve. © Courtesy Peter Rauch.

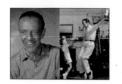

Fred Astaire wearing the scarf as an ascot, rather than as a belt around his waist, 1957. © The Kobal Collection.
Fred teaching his son, Fred Jr., to dance, in the living room of their Beverly Hills home, January 1940. © George Karger/Pix Inc./Time Life Pictures/Getty Images.

Astaire with George Murphy and a reverent Mickey Rooney at MGM. George Murphy was Astaire's fellow song-and-dance man in *Broadway Melody of 1940*. Astaire liked to wear a double-breasted suit with a button-down shirt. © All rights reserved.

Tweed sports jackets were Astaire's favorite. He invariably paired them with gray flannels, brown suede chukka boots or oxfords, plain button-down shirts, and regimental striped neckwear. This jacket is a Shetland tweed in an unusual "pheasant's eye" woven pattern. © Collection Christophe L. In the consummate top hat, white tie, and tails, the famous "shooting" scene in *Top Hat*, 1935. Astaire had reprised this dance number from an earlier stage production. © All rights reserved.

Astaire rehearsing. Ease and grace, and apparent nonchalance derived from endless hours of rehearsals. Astaire was a perfectionist who would practice a nuance for hours to achieve the effect he wanted. © Collection Christophe L.

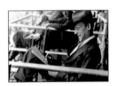

Astaire at the Santa Anita racetrack, mid-1930s. Racehorses were a particular passion, and he owned a string of them over the years. Between 1945 and 1948 his horse Triplicate amassed $240,000 in winnings for Fred. It seems natural that a man so aware of grace and beauty in movement would have a special love for horses. © Corbis.

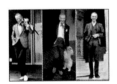

Fred loved animals, and his pets included, over the years, a number of dogs, cats, and even a few cockatiels. Here he is dancing with one of his Siamese cats on his shoulder, 1962. © John Swope/Time Life Pictures/Getty Images. Fred with his pet cockapoo Allison, at his Beverley Hills home, 1968. © Corbis. Still slim and trim in his seventies, and dapper as a blade. © All rights reserved.

Fred and Rita Hayworth kick off some high-spirited steps for the *Picture Post* cover in March 1943, demonstrating the "Shorty George" dance number from their new film *You Were Never Lovelier*. © IPC Magazines/Hutton Archive/Getty Images. The high-spirited Fred. © Rue des Archives, Paris, France.

Fred Astaire in *Funny Face*. © John Kobal Foundation/Getty Images.

79

Bibliography

Astaire, Fred. *Steps in Time*. New York: Harper and Row, 1959.

Babington, Bruce and Peter William Evans. *Blue Skies and Silver Linings*. Manchester, UK: Manchester University Press, 1985.

Billman, Larry. *Fred Astaire: A Bio-Bibliography*. Westport, CT: Greenwood Press, 1997.

Gallafent, Edward. *Astaire and Rogers*. New York: Columbia University Press, 2002.

Giles, Sarah. *Fred Astaire: his Friends Talk*. New York: Doubleday & Company, 1988.

Green, Stanley, and Burt Goldblatt. *Starring Fred Astaire*. New York: Doubleday & Company, 1977.

Lahr, John. "Revolutionary Rag," *The New Yorker*, March 8, 1999, 77-83.

Moers, Ellen. *The Dandy: Brummell to Beerbohm*. London: Secker & Warburg, 1960.

Mueller, John. *Astaire Dancing: The Musical Films*. New York: Wings Books, 1985.

Satchell, Tim. *Astaire: The Biography*. London: Hutchinson Ltd., 1987.

Thomas, Bob. *Astaire: The Man, the Dancer*. New York: St. Martin's Press, 1984.